Having Fun with
SCULPTURE

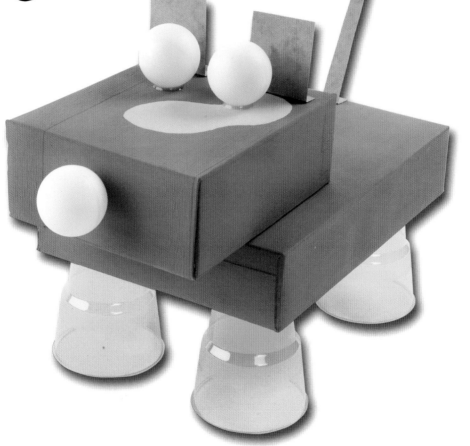

Sarah Medina

WAYLAND

First published in 2007 by Wayland

Copyright © Wayland 2007

Wayland
338 Euston Road
London NW1 3BH

Wayland
Hachette Children's Books
Level 17/207 Kent Street
Sydney, NSW 2000

Medina, Sarah
 Having fun with sculpture. – (Let's do art)
 1. Sculpture – Technique – Juvenile litarture
 I. Title
 731.4

Written by Sarah Medina
Produced by Calcium
Design and model making by Emma DeBanks
Photography by Tudor Photography
Consultancy and concepts by Lisa Regan

ISBN 978-0-7502-4892-1

Printed in China

Wayland is a division of Hachette Children's Books.

Contents

Modelling Fun!

Sculptures are three-dimensional (3-D) models of scenes, people and objects. The projects in this book use different types of materials to make sculptures. Ask an adult to help you find them.

- Bells and beads
- Card, magazines and newspaper
- Cardboard boxes
- Cotton bobbins
- Drinking straws
- Household items: cotton wool, pipe cleaners

- Self-hardening clay
- Cellophane and sequins
- Ping-pong balls
- Plastic bottles and cups

Note for adults
Children may need adult assistance with some of the project steps. Turn to page 23 for Further Ideas and for a recipe for *papier mâché* paste.

Read the 'You will need' boxes carefully for a full list of what you need to make each project.

Before you start ask an adult to:

- find a surface where you can make the projects.

- find an apron to cover your clothes, or some old clothes that can get messy.

- do things, such as cutting with scissors, that are a little tricky to do on your own.

Wind Chime

Hear your chime tinkle as it blows in the wind!

You will need

- 1 brass ring
- 4 small metal bells
- 16 chunky beads
- 12 colourful straws
- 4 pieces of string, 60cm long
- Hole punch
- Cardboard
- Scissors

1 Tie a knot at the end of each piece of string, and thread one bell onto each one.

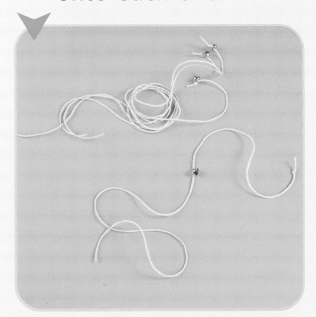

2 Cut the straws in half, and thread one straw and then one bead onto each piece of string.

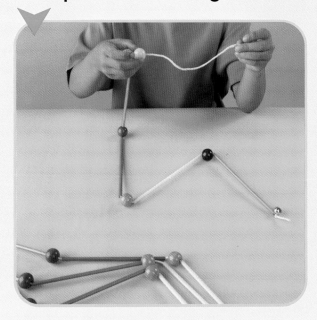

3 Repeat until you have used all the beads and straws.

4 Cut a 10cm circle from the cardboard and make four holes in it using the hole punch.

5 Thread string through the holes, and tie all four ends securely on to the brass ring.

! Ask an adult to help you when cutting straws!

Racing Car

Enjoy playing with this exciting racing car!

You will need
- 4 cotton bobbins
- 1 large plastic bottle
- 2 straws
- Strips of newspaper
- *Papier mâché* paste (see page 23)
- Paintbrush
- Poster paints
- PVA glue
- Scissors

1 Cut the top off the plastic bottle.

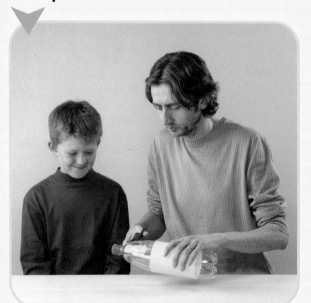

2 Glue strips of newspaper all over the bottle, including the ends, using *papier mâché* paste. Leave to dry.

 Ask an adult to help you when cutting plastic!

3 Glue the straws across the bottom of the bottle.

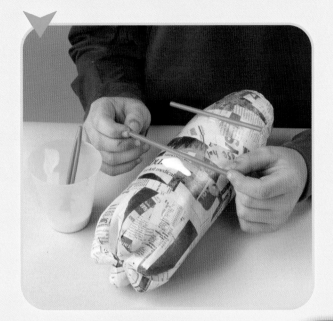

4 Thread a cotton bobbin on to both ends of each straw to make wheels, and glue to secure.

5 Paint your racing car to decorate it.

3-D Birthday Card

Make this unusual birthday card for a friend!

You will need

- Sequins
- 6 straws
- Cotton wool
- 2 sheets of card in different colours
- Felt-tip pens
- Pencil
- PVA glue
- Scissors

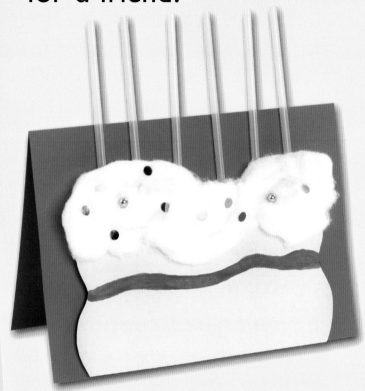

1 Fold one of the sheets of card in half.

2 On the second piece of card, draw the outline of a birthday cake, and cut it out.

3 Colour the cake using felt-tip pens, and decorate it by glueing on cotton wool for icing. Glue sequins onto the icing.

5 Put more glue onto the middle of the straws, and carefully stick the cake onto the straws.

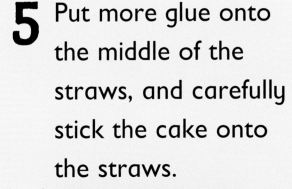

4 Glue the straws onto the front of the folded card.

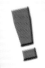 Ask an adult to help you when cutting card!

Junk Pet

It is easy to make a new family pet using old cardboard boxes!

1 Glue the two cardboard boxes together. Paint them and leave them to dry.

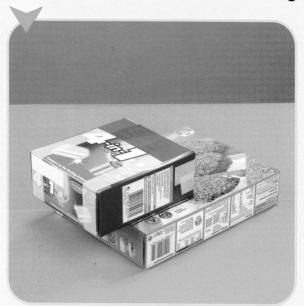

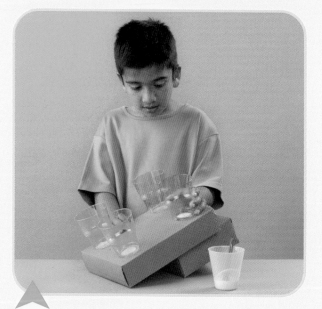

2 Turn the boxes upside down and glue on four plastic cups for legs.

3 Glue ping-pong balls onto the head to make a nose and eyes.

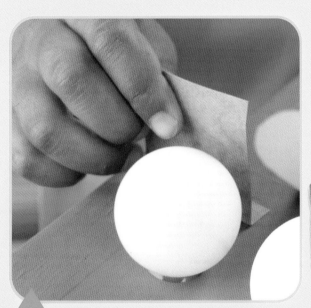

4 Cut out two small rectangles of card, fold at the bottom and glue onto the head to make ears.

5 Cut out a long tail from card and paint it. Fold it at the bottom and glue onto the body.

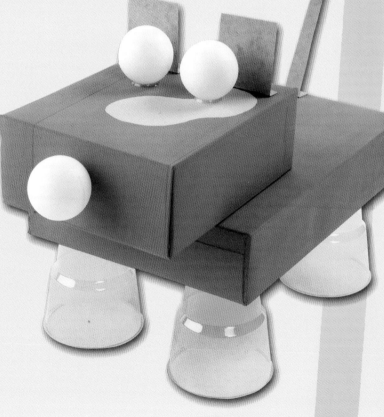

 Ask an adult to help you when cutting card!

13

Self-Portrait

Make a model of yourself for one of your favourite people.

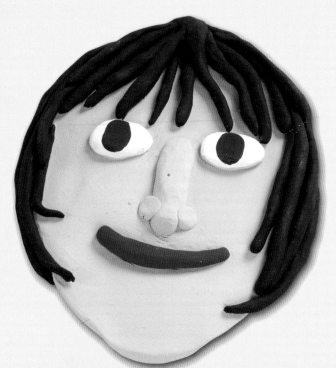

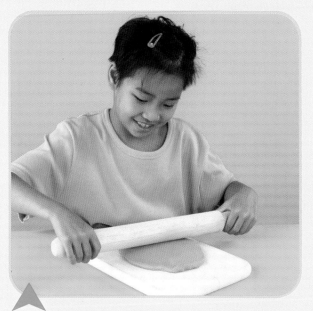

1 Look in a mirror, and see what shape your face, eyes, nose and mouth are.

2 Roll out a large oval shape of clay for your face.

3 Make two eyes from the clay and stick them onto the face.

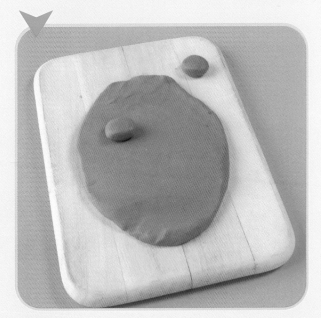

4 Make a nose and a mouth from the clay and stick them onto the face.

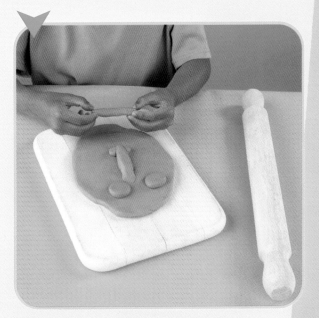

5 Roll long, thin strips of clay for hair and stick them onto the face. Now paint your model!

Garden Sculpture

Decorate your garden with this modern sculpture.

You will need
- 1 large plastic bottle
- Cellophane in different colours
- 3 coloured plastic cups
- A 30cm piece of string
- PVA glue
- Scissors

1 Fill the plastic bottle with scrunched-up cellophane.

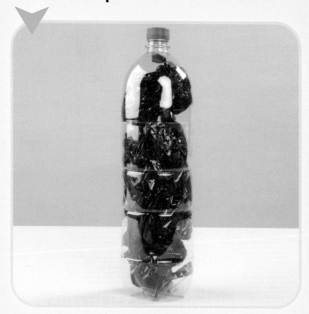

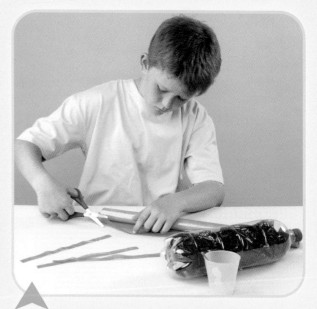

2 Cut a strip of cellophane and glue it around the top of the bottle.

3 Glue each cup onto the bottle. Hold each cup in place until the glue is dry, so it does not slip.

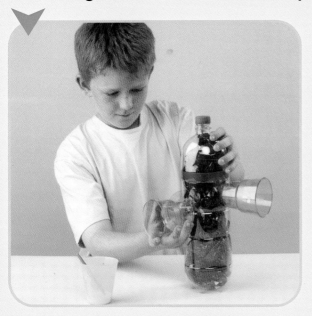

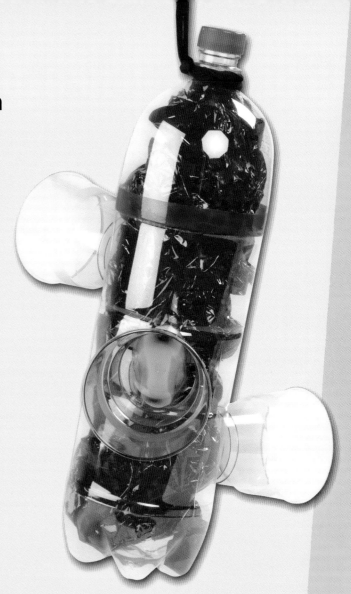

4 Tie a piece of string firmly around the top of the bottle.

5 Hang your sculpture in the garden.

 Ask an adult to help you when cutting cellophane!

Piggy Bookends

Keep your books tidy with these cute bookends!

1 Fill the jug with sand. Pour it through the funnel to half fill each bottle. Screw on the bottle caps.

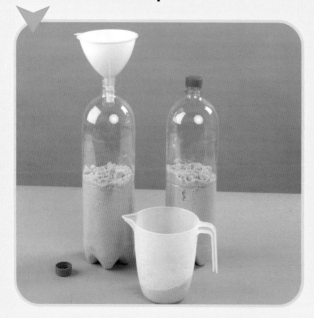

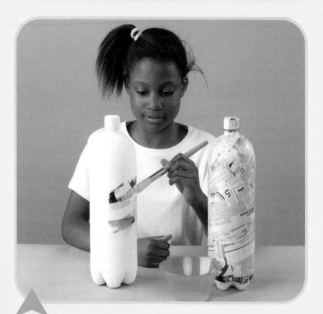

2 Using *papier mâché* paste, glue newspaper over both bottles, and paint them when dry.

3 Cut ears from the pink card, fold the ends over and glue onto the top of the bottle.

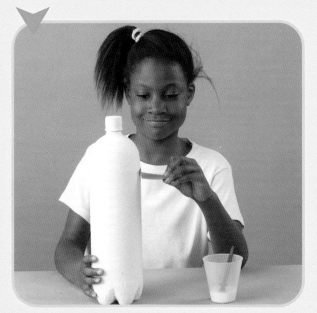

5 Draw eyes onto each bottle.

4 Curl the pipe cleaners around a pen, glue one onto the end of each bottle to make a tail.

 Ask an adult to help you when cutting card!

Sweet Shop

Make this yummy shop with a friend and then enjoy playing with it!

You will need

- 2 cardboard boxes – 1 large and 1 small
- Colourful sweets
- Cardboard
- Paper
- Paintbrush
- Poster paints
- PVA glue
- Scissors

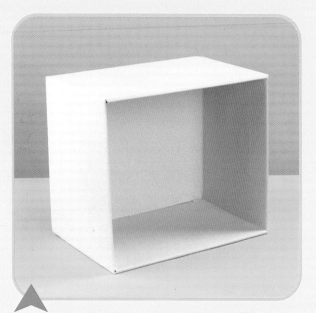

1 Stand the large cardboard box on its side, and paint it inside and out.

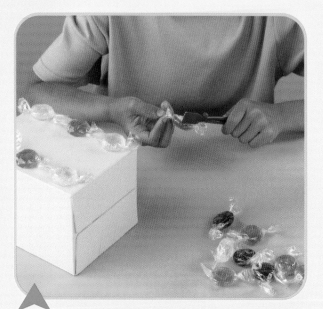

2 Paint the small box. When dry, glue sweets onto the box.

3 Put the small box inside the large one, for the shop counter.

4 Cut out a piece of cardboard to fit onto the shop front. Fold over one edge of the cardboard to make a hinge.

5 Paint the shop front in the same colour as the large box. When it is dry, paint a door, a window and a shop name onto the shop front.

 Ask an adult to help you when cutting card!

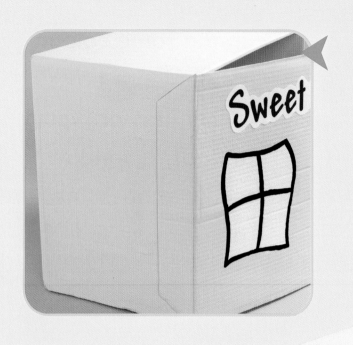

6 Paste glue along the hinge of the shop front and stick it onto the shop.

7 Your sweet shop is now ready to play with!

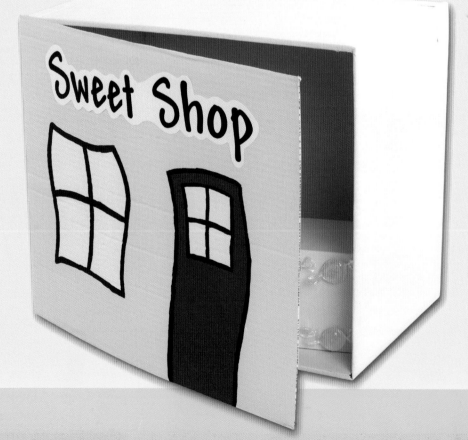

Further Ideas

Once a child has finished the projects in *Having Fun with Sculpture*, they can add some other exciting finishing touches to them. Here are some suggestions for each project:

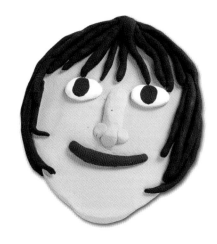

Wind Chime
Cut thin strips of coloured cellophane and tie them onto the mobile. Watch them float in the wind!

Racing Car
Decorate the car with colourful stripes and with pictures or logos cut from magazines.

3-D Birthday Card
Make tiny presents using card decorated with paints and sequins. Glue them around the cake.

Junk Pet
Make a basket for the pet using a box lined with colourful fabric.

Self-Portrait
Look carefully at your face again and paint any extra features, such as freckles, onto your model.

Garden Sculpture
Glue leaves, flower petals or pebbles from the garden onto the sculpture.

Piggy Bookends
Use different-coloured paints to make crazy-coloured piggies!

Sweet Shop
Make an empty matchbox into a shop till to keep money in on the counter. Add more empty boxes as you get them, so you can have a full pick'n'mix counter of tiny sweets!

How to make *papier mâché* paste
Stir equal amounts of PVA glue and water in an old container with a lid. The paste will last for several days if you keep the lid on.

Further Information

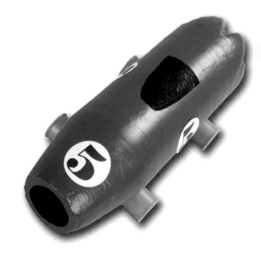

With access to the Internet, you can check out several helpful websites for further arts and crafts ideas for young children.

Glossary

logo a small picture or symbol
papier mâché a paste of glue and shredded paper which sets hard when dry
sculpture a 3-D model of something
self-hardening clay clay that gets hard and dry on its own, without being baked in an oven
three-dimensional (3-D) tall, deep and wide, like a model, instead of flat like a picture

Index